This Book Belongs To:

Dear Parents,

This coloring book is perfect for kids in preschool to early elementary, and will provide hours of coloring fun.

- 100+ big simple cute coloring pages, all different designs!
- Big simple pictures perfect for beginners
- Thick outlines and large areas to color

Coloring is fun for kids and has lots of benefits including:

- Improves fine motor skills
- Contributes to better handwriting
- Color awareness and recognition
- Improves focus and hand eye coordination

Have fun!

We would love to hear from you. If you have feedback, please email us at feedback@littlephone.co

Congratulations!

is now a certified super coloring expert

Date

Made in the USA
Middletown, DE
10 November 2018